Get set... GO!

Printing

Ruth Thomson

Contents

℗ CHILDRENS PRESS®
CHICAGO

Getting ready

Have you ever tried printing?
It is a way of transferring a design
from one surface to another.
You can repeat the design
over and over again.

This book shows you all kinds
of printing ideas to try.
Cover your table with newspaper.
Wear an old shirt or a smock
to protect your clothes.
Keep a damp rag handy
for wiping your hands.

For some projects,
you will need printing rollers.
Buy these from an art supply store.

You will also need a plastic tray
and a piece of thick plastic or formica
to use as a printing sheet.

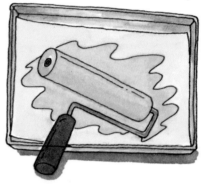

(You will squeeze the ink onto the
tray. Then you will coat the roller
with ink. Then you will roll it on
the printing sheet to spread the ink
evenly. See page 14.)

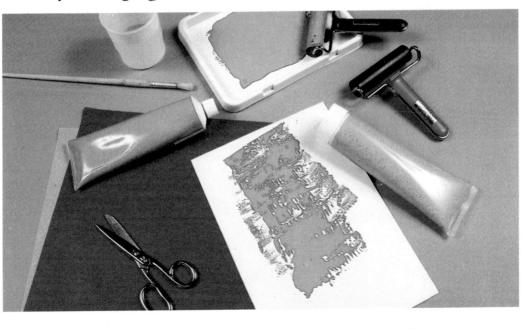

Handprints

Get ready

✔ Roller ✔ Paint

✔ Plastic tray ✔ Paper

. . . Get Set

Squeeze some paint onto the tray.
Spread it evenly with the roller.

⟿⟿⟿ *Go!*

Press your hand into the paint.
Then press your painted hand
onto some paper.
Make a pattern of handprints
in different colors.

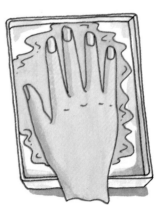

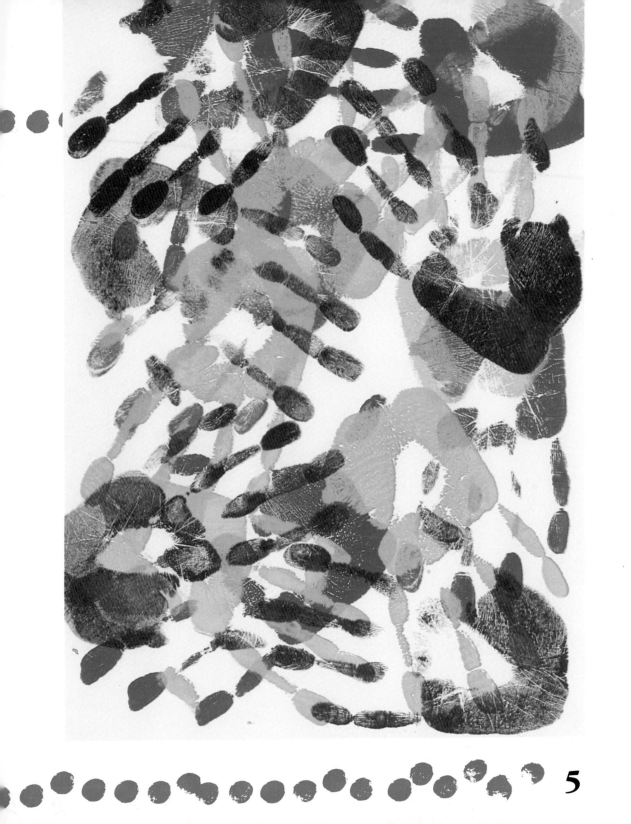

Fabric prints

Get ready

- ✔ Old knit glove
- ✔ Plastic tray
- ✔ Water-based paint
- ✔ Roller
- ✔ Paper

. . . Get Set

Squeeze some paint onto the tray.
Spread it evenly with the roller.

⬧⬧⬧ *Go!*

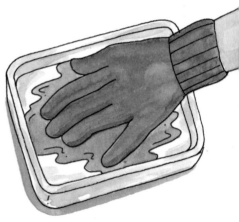

Put the glove on one hand.
Press it into the paint.
Then press the painted glove
onto some paper.
The print has the same texture as the glove.
Try printing other kinds of fabric
by wrapping them tightly around your hand.

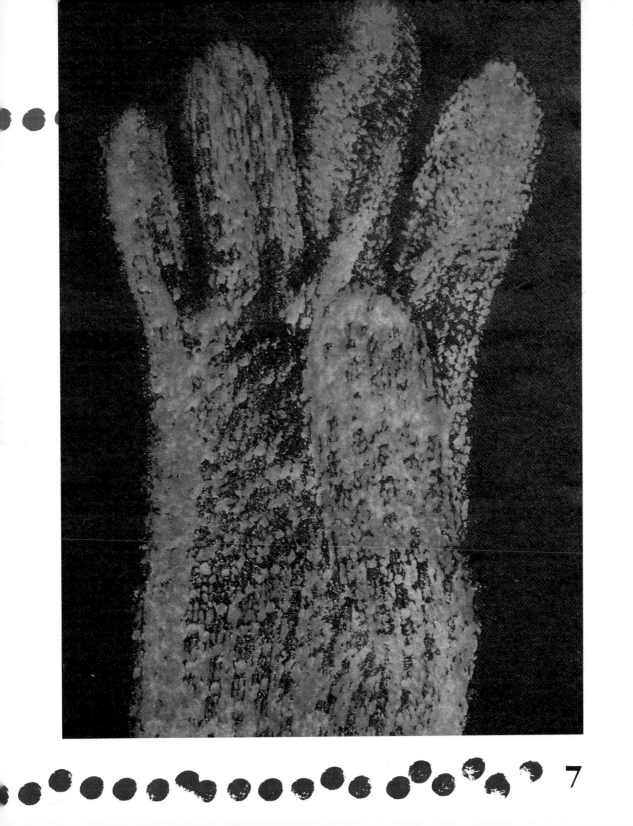

Smudge prints

Get ready

✔ Paper
✔ Different colored paints

. . . Get Set

Fold a piece of paper in half.
Open it out again.
Dribble a pattern of paints
onto one half of the paper.

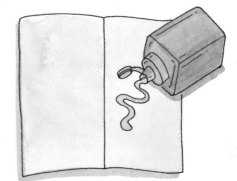

 Go!

Fold over the clean side
of the paper.
Rub it gently all over.
Open the paper to see
the print you have made.

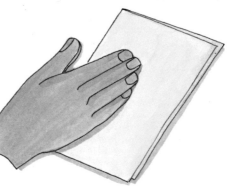

8

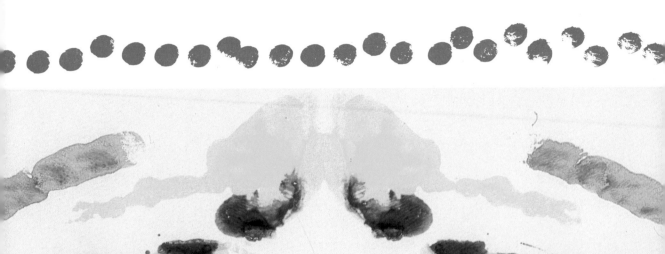

9

Sponge block prints

Get ready

- ✔ Ballpoint pen
- ✔ Pieces of sponge
- ✔ Safety scissors
- ✔ Cardboard
- ✔ Glue
- ✔ Glue brush
- ✔ Poster paints
- ✔ Old saucers
- ✔ White paper

. . . Get Set

Draw shapes on the pieces of sponge.
Cut them out.
Cut the cardboard into pieces.
Glue each sponge shape onto a piece
of cardboard and let it dry.

 Go!

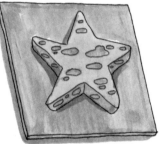

Coat the shapes with paint.
Print a pattern with them.
Sponge printing is a good way
to make your own wrapping paper.

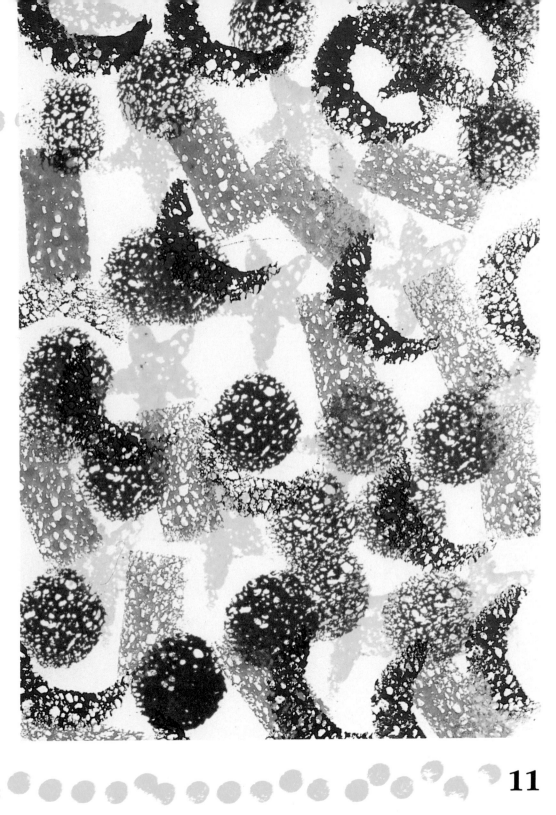

Clay block prints

Get ready

✔ Modeling clay
✔ Teaspoon
✔ Poster paint

✔ Sponge and
 old saucer for
 each color

✔ White paper
✔ Wet rag

. . . Get Set

Shape the clay into a ball.
Thump it on the table
to flatten one side.
Press a pattern into the flat
surface with the teaspoon handle.

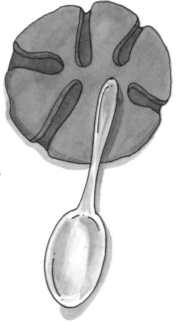

⤳⤳⤳ *Go!*

Coat the clay pattern with paint.
Print a design with it.
Wipe the clay clean with the rag, coat it
with a different color, and print with it again.

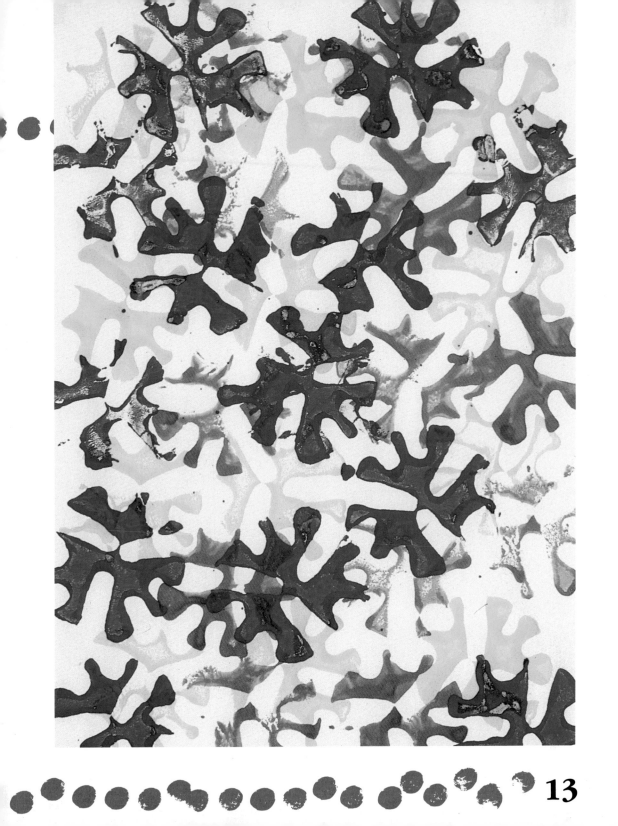

Corrugated cardboard prints

Get ready

- ✔ Corrugated cardboard
- ✔ Pencil
- ✔ Safety scissors
- ✔ Glue
- ✔ Smooth cardboard
- ✔ Plastic tray
- ✔ Printing inks
- ✔ Roller
- ✔ Paper

. . . Get Set

Draw shapes on the corrugated cardboard. Cut them out and glue them onto a piece of smooth cardboard. Let them dry.

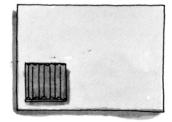

⇒ ⇒ ⇒ *Go!*

Coat the roller in ink (see page 3). Roll it over the cardboard block. Turn the block over. Press it onto a sheet of paper.

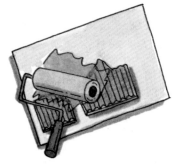

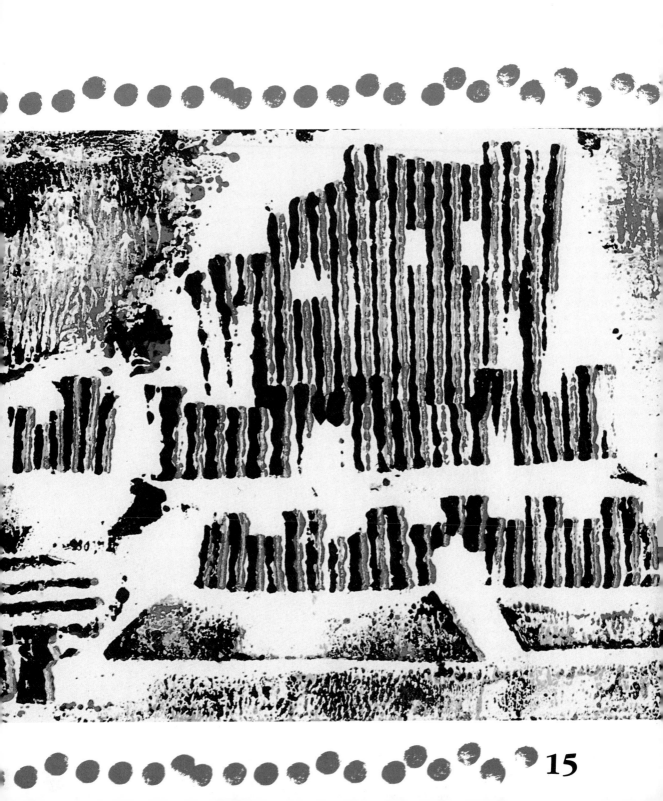

15

Postcard prints

Get ready

- ✔ Thin cardboard such as a postcard
- ✔ Paper clips
- ✔ Old saucer
- ✔ Paint
- ✔ Sponge
- ✔ Paper

. . . Get Set

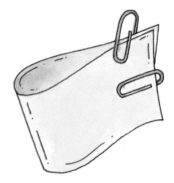

Bend the cardboard in half
to make a loop.
Fasten the edges with paper clips.
Put the sponge on the saucer
and soak it with paint.

➤➤➤ Go!

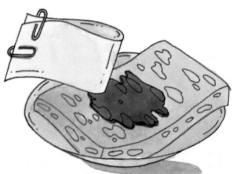

Dip the thin edge of the
cardboard into the wet sponge.
Print different patterns on the paper.

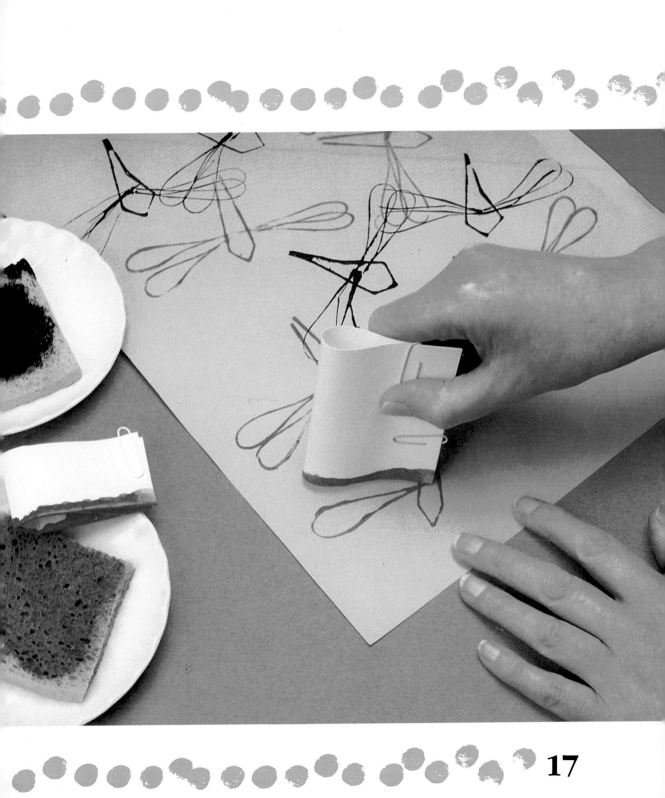

Glue block prints

Get ready

✔ Cardboard ✔ White glue ✔ Two rollers
✔ Pencil (in a tube ✔ Printing tray
✔ Paper with a nozzle) ✔ Printing inks

. . . Get Set

Draw a picture on the cardboard
in pencil.
Dribble glue along the lines.

Go!

Coat one roller with ink, and
use it to spread ink over the printing tray.
Put your picture, face down, on the wet ink.
Roll gently over the back of it
with the clean roller.
Print the inked picture on the paper.

Junk prints

Get ready

✔ Junk materials such as cork, empty matchbox, cardboard tube, wood, fabric scraps

✔ Thick poster paint
✔ White paper
✔ Sponge
✔ Old saucer

. . . Get Set

Put the sponge on the saucer.
Pour paint onto it.
Press the junk materials
into the paint-soaked sponge.
Print them on the white paper.

⚞⚟⚞⚟⚞⚟ *Go!*

Overlap the shapes
of your junk materials
to make a large picture.

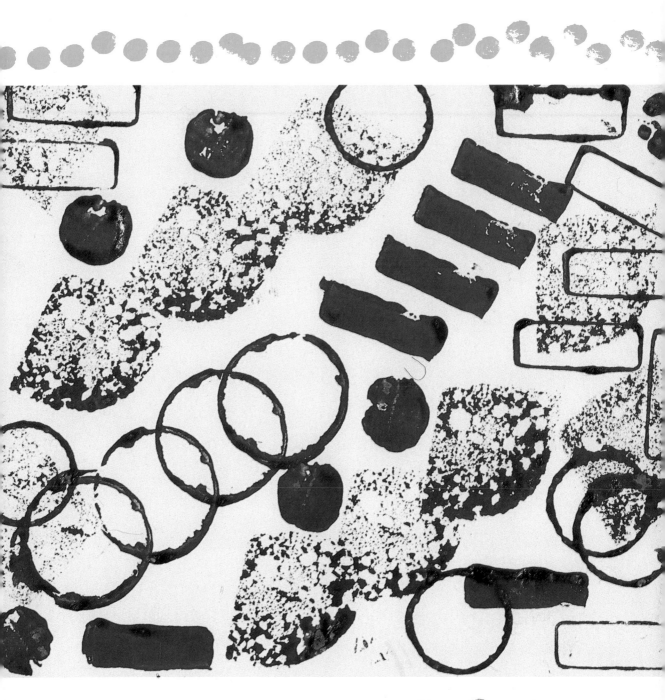

String pulls

Get ready

- ✔ Piece of string about a yard long
- ✔ Colored ink
- ✔ Old saucer
- ✔ Paintbrush
- ✔ Paper

. . . Get Set

Pour the ink into the saucer.
Use the paintbrush to cover
the string with ink, leaving one
end of the string clean to hold onto.
Fold the paper in half.
Put the string inside the fold,
curled around in a circle.

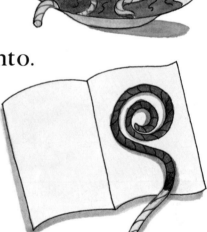

Go!

Close the paper and press it down firmly.
Gently pull the string out.
It makes a swirly pattern.

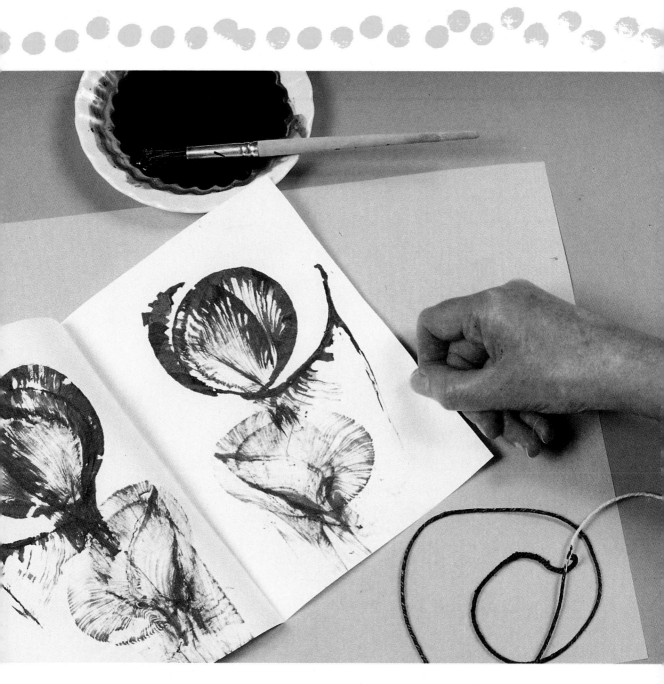

Index

Photography: Chris Fairclough
Cover photography: John Butcher

Editor: Pippa Pollard
Cover design: Mike Davis
Artwork: Jane Felstead

Library of Congress Cataloging-in-Publication Data
Thomson, Ruth.
 Printing / by Ruth Thomson.
 p. cm. — (Get set— go!)
 Includes index.
 ISBN 0-516-07992-1
 1. Handicraft—Juvenile literature. 2. Block printing—Juvenile
literature. 3. Relief printing—Juvenile literature. [1. Handicraft.
2. Block printing. 3. Relief printing.] I. Title. II. Series.
TT160.T39 1994
 761—dc20 94-16913
 CIP
 AC

1994 Childrens Press® Edition
© 1993 Watts Books, London, New York, Sydney
All rights reserved. Printed in the United States of America.
Published simultaneously in Canada.
1 2 3 4 5 6 7 8 9 0 R 03 02 01 00 99 98 97 96 95 94